The Last Flowers of Manet

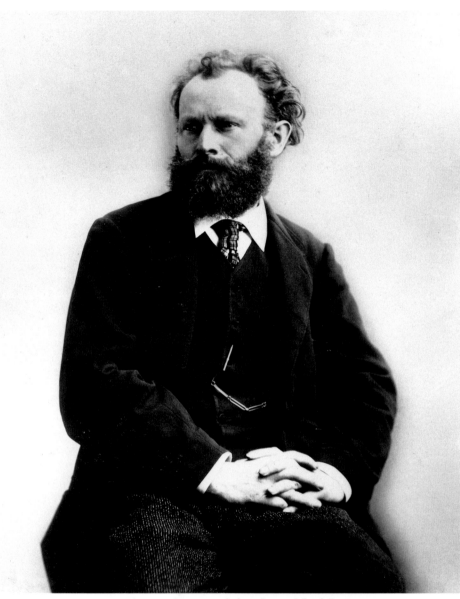

MANET. *Photograph courtesy Galerie Durand-Ruel, Paris*

THE LAST FLOWERS OF MANET

by Robert Gordon and Andrew Forge

Translations from the French by Richard Howard

HARRY N. ABRAMS, INC., PUBLISHERS, NEW YORK

For Orange

NOTE: These flower pictures were painted between 1881 and 1883. However, no one knows the order in which they were painted. The catalogue raisonné of Manet's oeuvre is inconclusive in this respect. Sufficient information from the past is lacking, whether from the backs of the paintings themselves, Manet's note-books, or exhibition and auction catalogues. In many cases, titles have not been used with precision. For want of a better order, the authors have grouped the pictures according to the shape of the vases in which the flowers were painted, beginning the series with the roses in a champagne glass that have obvious affinities with the roses in *A Bar at the Folies-Bergère*, and ending with the two paintings that legend connects with Manet's last days.

EDITOR: ROBERT MORTON
DESIGNER: JUDITH HENRY

Library of Congress Cataloging-in-Publication Data
Gordon, Robert, 1946–. The last flowers of Manet.
1. Manet, Edouard, 1832–1883—Criticism and interpretation.
2. Flowers in art. 3. Still-life painting—19th century—France.
I. Forge, Andrew.
II. Title.
ND553.M3G67 1986 759.4 86–3328
ISBN 0–8109–1422–0

Text copyright © 1986 Andrew Forge

Illustrations copyright © 1986 Harry N. Abrams, Inc.

Published in 1986 by Harry N. Abrams, Incorporated, New York
Times Mirror Books

Printed and bound in Japan

THE SIXTEEN FLOWER paintings reproduced together here for the first time were painted during the last months of Manet's life. He had been ill for several years and, in spite of heroic treatments, his condition was getting worse. Gradually he had come to accept the curbs of his illness. He had been working on a smaller scale. He had been working in pastel, a less demanding medium than oil. His last major composition had been *A Bar at the Folies-Bergère,* which had been completed in time for the Salon of 1882, a year before his death. Working on that, witnesses tell us, he had only been able to paint for limited periods, then would rest on a couch to look at what he had done and chat with friends.

So these flower paintings belong to a period of decline and, one must imagine, of occasional despair. But even at his most bitter moments Manet's spirits would revive at the sight of flowers. "I would like to paint them all," he would say.

Born in Paris in January 1832, Edouard Manet was the son of a senior official in the Ministry of Justice. Educated at the Collège Rollin, he first wanted to become a naval officer. He failed the entrance exams to the Ecole Navale, but shortly afterwards gained a berth on the training ship *Havre et Guadeloupe,* setting sail for Rio de Janeiro at the end of 1848. By the time he was back in France the following summer he had decided that he wanted to train as an artist. He persuaded his family and enrolled in the studio of Thomas Couture, the painter of the famous *Romans of the Decadence.* Couture was one of the least conservative teachers of the time and although Manet had a stormy relationship with him, he remained in his studio for six years. During these years he traveled a good deal, visiting the Netherlands, Germany, and on more than one occasion, Italy. He copied widely in the museums.

His first submission to the Salon, in 1859, was called *The Absinthe Drinker.* It was a dark image of a figure from the Paris streets, a ragpicker, cloaked, tophatted, with

something crazy about his pose, his left foot thrust forward in a gesture that was both mincing and sinister. The man was recognizably from the world of Baudelaire:

> A ragpicker stumbles past, wagging his head
> and bumping into walls with a poet's grace,
> pouring out his heartfelt schemes to one
> and all, including spies of the police.

The inferred association with Baudelaire told against Manet. It was only a few years since certain poems from *Les Fleurs du Mal* had been banned as immoral. The painting was rejected by the Salon jury. Manet remarked of the picture that he had painted a figure he had seen with a simple technique he had learned from looking at Velázquez, adding that if his subject had been Spanish, people would have liked it.

Two years later the Salon accepted both his submissions, one of which, Spanish in style and subject matter, *The Spanish Singer*, received an honorable mention from the authorities and lusty praise from Théophile Gautier writing in a government newspaper. Gautier liked the Spanish atmosphere. Other critics attacked it. For a few of Manet's contemporaries it signaled the appearance of a completely new and independent vision. A group of painters and critics, among them Baudelaire, with whom Manet was already friendly, called at his studio to congratulate him.

In the spring of 1863 the Emperor authorized an exhibition of work that had been rejected by the Salon committee. Manet's *Luncheon on the Grass*, his most ambitious painting to date, quickly became a center of scandal. Manet had become notorious and for the rest of his life would be under various degrees of critical fire. He was seen as the ringleader of the independent painters, particularly after be began to be supported by young liberal writers, Emile Zola in particular. Manet did not welcome his reputation as a rebel. He was not deflected from his ambition to gain fame and recognition through established channels—through the Salon—and when, after the war of 1870, the independents began to organize their own group exhibitions, he took no part in them.

Luncheon on the Grass was not an easy picture to come to terms with. What its first

public saw was its rawness: the street clothes of the two men who lounge on the grass; the recognizable features of their totally naked companion, a well-known model called Victorine Meurent; and the open, frank way in which her body was painted, without idealized drawing or continuous modeling. Her nakedness is genuine, unshaded by simpers and downcast eyes but lit by her challenging worldly stare. And there was no story to explain this extraordinary scene. It was like a prank, a fantasy so unselfconsciously realized as to appear banal.

Hardest of all to accept or to fit into any existing critical framework was the unprecedented compound of old and new. Manet had already been accused of plagiarizing the Spanish masters and was to be so again. *Luncheon on the Grass* was addressed to certain images of the sixteenth century, to Raphael via Marcantonio and to Giorgione. It arrived at its startling, vivid presence through the museums. But Manet's borrowings were directed towards an uncompromising modernity.

Victorine appeared again when the Salon accepted *Olympia* in 1865. Now she was attended by a black maid with a huge bunch of flowers, and a black cat that arches its back and spits. She reclines, naked except for a black ribbon and a bangle, and looks directly outward. It was as if a Titian Venus had been scraped down, its golden glow switched to a hard studio light, its diffuse and luxurious eroticism focused into an unnerving personal challenge.

Most of Manet's painting involves some sort of paraphrase or transformation of an earlier model. He paints in the language of pictures to which he brings a remarkable immediacy. His concern is with images, and it is this that distinguishes him completely from Monet, with whom he became close friends and whose work he greatly admired. Monet's lifelong preoccupation was with what he called nature, with the observed world and with observation itself, reconstructed in color. The difference between the two remained just as great even after Manet had adopted the palette and to some extent the working methods of his younger colleague.

This was not to happen until after the war of 1870, during which Manet served in the National Guard in the defense of Paris. With the return to normal life, his fortunes with the public began to improve. In 1873 he showed *Le Bon Bock*, a picture of a fat man smoking a clay pipe with beer at his elbow. Both in style and subject it evoked

Frans Hals. It was the nearest he ever came to pastiche. When, only ten years later, Manet's obituaries appeared, it was to the painter of *Le Bon Bock* that they referred.

Le Bon Bock was painted in the brown tones of a seventeenth-century painting. Two years later, the painting called *Argenteuil* that he showed at the Salon was in the fully developed Impressionist palette. Manet had spent part of the summer near the riverside town where Monet was living, and had worked with him. He had planned a large painting of Monet and his wife at the water's edge, but in the end he used two models. The painting was in any case a tribute to Monet's work. The couple pose against a background of blue water and sailing boats. In the distance, under a summer sky, are trees and factory chimneys. The whole painting vibrates in the clear blond tones of Impressionism, but it is more a painting about Monet and his way of working than it is an essay in Impressionism. Manet has transposed Monet's mode of direct painting into an idiom, a way of picturing contemporary life that he uses with as much verve and imagination as he had earlier brought to the idiom of Velázquez or Hals.

Manet's illness had first showed itself in 1879 when he had developed an inflammation of the legs. His doctors advised him not to climb stairs. He leaned on a cane. In the late summer of that year he took hydrotherapy treatment at a clinic in Bellevue. The treatment was painful and exhausting but he was determined to be cured. From now on summers were spent out of Paris, in itself a trial. The country was all right, he told friends, for those who are not forced to live there. For Manet, the complete Parisian, to be away from society for more than a few days was torture.

It seems likely that he was suffering from the last stages of syphilis, contracted in his youth. For several years his illness took ups and downs. He was able to work, although in constant pain.

He died in the spring of 1883, on the 30th of April, twelve days after his left leg had been amputated. It was a sordid, miserable death for a proud, elegant, society-loving man. He was widely mourned. Among his pallbearers were Zola, Théodore Duret, Fantin-Latour, Monet, and Antonin Proust, Manet's oldest friend, his biographer, and formerly the Minister of Fine Arts in Gambetta's cabinet.

A degree of official recognition had come to Manet in the last two years, but it had been grudging and equivocal. The jury of the Salon had given him a second-

class medal in 1881. This at last allowed him to show what he pleased at the annual exhibition. The Légion d'honneur had followed, forced through by Proust against considerable opposition. But it had all happened too late.

Death is always arbitrary and yet the mind imposes the sense of an ending, the closing of a curve. Perhaps particularly in the case of an artist with whom the stages of growing and self-understanding—features of anyone's life—are imprinted on the work he leaves behind and are hardly to be separated from our understanding of it. Artists who die young have a special aura and their precocious achievement is lit by their early end. This view is sentimental and obscure; but it seems more natural to confess to it than to step outside it. The imagination moves through time backward and forward and can as little guard itself from doing this than the body can guard itself from the flow of time in one direction.

An artist who dies in his middle years? He is cheated of the flares of an early death and the glow of old age. Those violent middle years, the battles for final self-definition, are suddenly snapped off. Manet's life does not describe a curve but the beginning of one, broken with an ugly jerk. It is incomplete, off-stride. We will always feel that he died too soon or too late, and that the essential struggle that would have decided what kind of artist he was, was unresolved.

Just as on the mundane level of his life Manet appeared to be both conventional and bohemian, conformist and rebel, so at the serious level of his work he presented contradictions that even now put our reading of his work under extreme tension. Somehow the contradictions have to be kept in play. The frankness of his painting, even in a certain sense its naiveté, is precisely what allowed him to bring into the world his extraordinary intuitions about pictures and their relationship to life. His intentions were as sophisticated as any painter's had ever been; they could only be realized in simplicity.

The one thread that binds his whole output together is the directness of his painterly verve. His brush is alive, responsive, engaged. His sense of time is unique. On the centenary of Manet's birth, Henri Matisse was asked to comment on his legacy. Manet, he wrote, was "the first painter to have translated his sensations immediately."

He liberated instinct. "He was the first to *act by reflex* and thereby to simplify the painter's métier."

In the 1860s this vivid sensual directness was well understood in the context of still life painting. But Manet practiced an ambitious figure art and the result was baffling. Everything that made a figure painting comprehensible was thrown into doubt. His figures do not behave, or move, or glance within the structure of a story. His borrowings from the Old Masters were themselves ambivalent. They did not function as quotations, nor offer a framework of dignity, but, on the contrary, seemed to throw into even more disturbing relief his vision of a present in which nothing was stable anymore.

This complexity is arrived at through the immediate language of painting. He eliminates everything that is indirect, affected, or merely descriptive. He is at the opposite pole from an illustrative painter like Meissonier or James Tissot. Manet's painting is vivid and firsthand. The still life painter and the problematic painter of modern life are one.

These last flower paintings, then, stand with his work as a whole. They may be rear guard actions, but they are much more than the pastimes of a dying man. His illness accounts for their size: the largest is only 56 by 46 cm, the smallest is 26.5 by 21 cm. He was contemplating an even smaller scale, and not long before his death had approached a miniature painter for instruction in the craft. But only a few years earlier his ambition had been flowing in the opposite direction. He had been looking for an opportunity to expand beyond the limits of easel painting.

In 1879, at about the time that his illness had first shown itself, he had approached the authorities with a grand proposal. The Hôtel de Ville, destroyed during the Commune of 1871, had been rebuilt. Manet had addressed a letter to the Prefect of the Seine with an offer to decorate the chamber with:

> a series of compositions representing—in the now-hallowed expression which clearly represents my idea—*the belly of Paris*, with various institutions functioning in its midst, the public and commercial life of our time. Such subjects would include Paris-Markets, Paris-Railways, Paris-Port, Paris-Under-

ground, Paris-Races, and Parks. For the ceiling, a gallery around which would circulate, in appropriate attitudes, all those now alive who, in the civil realm, have contributed or are contributing to the wealth and greatness of Paris.

Nothing came of the proposal. The Prefect does not seem to have answered Manet's letter. It is fascinating to speculate on what Manet would have done if he had accepted the proposal. The decoration of a government building would have been a public enterprise, involving completely different terms from easel painting. No painter, however individualistic, could have ignored that aspect of the task. Of course we may wonder whether Manet really expected his proposal to be taken seriously. He may have sent it off lightheartedly. But he would hardly have written as he did if his desires had not been serious.

In fact, according to Antonin Proust, Manet had wanted to paint a great public decoration all his life. He remembers Manet holding forth with considerable sarcasm about what would be expected by the public: allegory, above all; the wines of France represented by a brunette for Burgundy, a blond for Champagne; or Gods; or the history of Paris. "As for the New, no use whatever! And yet how interesting—later on —it would be to have portraits of those who are running the city now!" And he adds, "In Amsterdam, the group portrait of the Syndics stops us in our tracks. Why? Because it is the true impression of something seen."

Everything that Manet ever did depended upon its particulars, of observation and of execution. How did he imagine himself working on the scale of a public decoration, a scale at which the unity of conception and execution that was the hallmark of his work could not possibly hold?

Manet would also have had the problem of giving his scenes of modern Paris a general, representative aspect. On this point, there is perhaps a clue to be found in a series of paintings of the four seasons that he undertook in response to a commission from Antonin Proust. Only *Spring* and *Autumn* were completed. *Spring* was shown at the Salon of 1882, at the same time as *A Bar at the Folies-Bergère*. Both pictures are half-length portraits of close friends of Manet. The sitter for *Spring* was Jeanne Demarsy, for *Autumn*, Méry Laurent. Jeanne, in profile, has flowers in her hat, is

wearing a flowered dress and carries a lacy parasol. She is outdoors, seen against spring foliage and a blue sky. In *Autumn*, flowers again play an emblematic role but now they are entirely man-made: the model is seated, wearing furs and a muff, seen against a patterned Japanese fabric, blue, covered with embroidered chrysanthemums and button daisies, an artificial autumn garden under an artificial sky.

In both pictures the sense of the individual sitter is intense. We see Jeanne and Méry not as allegorical types, as generalizations, but as particular actresses playing their parts. The generalizing element is in their clothes and in the precision with which fashion and season pinpoint each other. It is essential to the credibility of the pictures that we can see the performance and can discern both the actress and the role.

From the first Manet had looked at clothes as a special focus of meaning. He loved clothes in themselves. When he was working on a portrait of Antonin Proust, Manet is reported as saying that he found nothing more difficult than to draw a top hat. A visitor in his studio, Jacques-Emile Blanche, claims that Manet repainted Proust's hat twenty times while he was there. We may be sure that the real challenge in this portrait of his friend as a man of fashion was not merely to draw *a* hat but to capture the precise line and angle and cut of Proust's hat, an observation that would exactly fix it in time. An observation, one might add, that could only be made by one who was in some sense also a man of fashion.

Manet's focus on clothes and fashion is but a facet of his awareness of the way that city life turns every aspect of life into signs. The same awareness is reflected in his treatment of flowers: Proust's boutonniere is as much a part of the man as his cane and gloves. Some of the mysterious excitement that we feel every time we face the naked *Olympia* is surely due to the enormous bouquet of flowers that is being handed to her by the black maid. There is a lover in the offing. A message is being delivered. Is he behind the dark curtains, his heart surely thumping with nervousness or desire; or is he where we are, making his entrance as we are making ours, and receiving in reply to his flowers the same challenging cool stare that is, so to speak, the answer that we get to our address to the painting?

. . .

The last flower paintings are all like bouquets. We can imagine each painting made as a response to a visit, perhaps started in company, the studio filled; or in silence. The bouquet is the trace of the departed visitor; the painting is like an answering visit—the flowers given in return now committed to another life, a picture.

These paintings are very far from the flower paintings of his contemporaries. They make the famous flower paintings of Fantin-Latour look stiff and dead, as if painted from accurate paper replicas of flowers. Manet's are marvelously alive. The moves of his brush bring each flower spontaneously into the world: paint becomes flower. Nor are they anything like the flowers that Renoir made toward the end of his life, in which roses become miniature stand-ins for the female body and are caressed into roundness in the absence of lips and cheeks. Manet's flowers are nothing but flowers, just as they come from the florist.

Nor are Manet's anything like Monet's. For Monet, landscape painter and gardener, flowers were a special condition of landscape. He turned to them when the weather was bad. He found his landscapes in them and his best flower paintings are unruly masses, heaps of growing things no more nor less formless than a clump of trees. On the occasions when he painted individual flowers, the results are as clumsy as his portraits.

The flower paintings must have been painted very quickly, in one or at most two sessions. Each painted flower is a likeness. The freshness and directness of the painterly expression is one with the freshness of the flowers. There is something magical about the way that he constructs them. One is continually aware of his strategy, of the inventive way, for example, in which he brings the background into play with the flowers, sometimes brushing the flowers cleanly against the background, sometimes folding the background back into the flowers and cutting out the edges of the petals with it. In *White Lilacs in a Crystal Vase* (page 39) a thin scumble of frosty greenish-white is laid down to receive the tiny cream-white flecks of paint that become the florets. The heavy, luxurious blossom heads come together with a snap. The sparkle of the flowers is identified with the sparkle of the paint, not just as it copies the flowers but in the wit with which it reconstructs them. To read the paint as white lilac is, in a sense, to share that wit. Van Gogh once commented on an earlier

painting of peonies by Manet. He wrote to his brother that the flower was "as free in the open air and as much a flower as anything could be, and yet painted in a perfectly solid impasto.... That's what I call simplicity of technique."

In the whole group of late pictures, the flowers are in glass vases. There are several that he uses, a squat one with feet, a round carafe, a straight-sided champagne glass; and there are two flat-sided ones with gilded decorations on the outside. No two are painted in the same way. Transparency is explored afresh in each canvas. Glass and water make prisms, distorting lenses, twisting the stems of the flowers, fragmenting them and throwing out unexpected flashes of color. The round carafe draws the light of the marble tabletop into itself. It stands out against the luminous blue-gray wall, a warm globe, the marble distilled into transparency.

This clear glittering focus of light in the glass receptacle stands in contrast to the flowers themselves, which give back the light in a completely different way. Their soft petals seem to absorb it like velvet or reflect it like snow.

The vigor of each flower is contained in a kind of gesture, the gesture of the form of the flower, as distinctive as a name, and the light they return to us is as particular to their form and color as the sense of likeness we experience in front of one of the pastels of his friends.

The contrast between this luxurious, flowery light and the transparent sparkle of the glass is inimitable and impossible to put into words: yet it is central to the quality of these paintings in which Manet was investing all the energy that he had left.

Although we cannot fail to project sadness into these paintings and a sense of parting, they are without self-pity. There is something debonair about them, a hint of the corsage, the boutonniere, an evening out.

The two roses in a champagne glass are siblings of the two that stand in front of the beautiful barmaid in *A Bar at the Folies-Bergère*, only now realized with a far greater intensity and a tight, indrawn elegance. The glass draws light into itself, into its narrow column. The roses unfold with an icy voluptuousness. The tabletop that they are standing on is the same marble that Mlle. Suzon, the model for the barmaid, had leaned upon, propping herself with the heels of her hands as she posed for the painting.

There are two paintings of white lilacs alone. Both have dark backgrounds. In one it is actually black, that cold Spanish black that had served Manet like a familiar all his life—the black of Velázquez, the black of top hats and frock coats, the black of cats and velvet ribbons and Berthe Morisot's hair. The white ghostly flowers are stark against the sooty background. Nowhere else is the light of the flowers as sharply contrasted with the brittle light of the glass. For all the innocence of its subject, it is a tragic, pitiless image. The black of the background falls slanting behind the flowers as though it were being drawn against the light like a curtain, threatening the snowy lilacs.

Only in one painting, *Flowers in a Crystal Vase* (page 35), do his spirits fail him. The blackish tone of the background seems to have spread on his palette, invading flowers and foliage, reducing them with weariness.

In these last paintings in which Manet gives himself over to painting pure and simple, to plying the mysterious and magical craft by which the light of the studio and the vivid, fugitive presence of the flowers are trapped forever in a few inches of paint, there is no backing away from his central concerns. He was, above all, the painter of the modern city. "Nature," the myth that sustained so many of his contemporaries, meant nothing to him. There is something sharp about these paintings. For all the sympathy with which he catches the luxurious turning of a rose or the dancing foam of lilac, the pictures are not sweet but dry, and their perfume has an astringent undertone.

If they are to be read—as all flowers offer themselves to be read—as emblems of beauty, purity, and the shortness of life, it will be in the context of the city, where change never ends and where time has escaped the seasons, and days and nights turn at their own speed. Autumn and Spring, a fur muff or a flowery dress, are *this year's* seasons only, figures in the city's speech as much as the white lilacs and red roses that Manet's visitors brought him out of season in the "winter" afternoons.

Antonin Proust was Manet's oldest friend. He published a memoir of the painter in a series of articles that appeared in La Revue Blanche *in 1897. Here he describes Manet's appearance as a youth.*

Manet was of average height and very muscular. Straight-backed, well-balanced, his loose-limbed, rhythmic gait gave his presence a special elegance. Though he often exaggerated his postures and affected the drawling speech of a Paris urchin, he could never be vulgar. You sensed his breeding.

Beneath a broad forehead, his nose plunged straight down, while his mouth curved up at the corners, giving him a teasing expression. His glance was bright, and his eyes, though small, were extremely mobile.

When he was quite young, he would fling back a head of long, naturally curly hair. At seventeen his hairline was already receding, but his beard had grown in, blurring the contour of his lips and leaving bare a smooth white chin. The lower part of his face had softened, harmonizing with the fine graying hair that framed his forehead. Few men have been so attractive.

ROSES DANS UN VERRE A CHAMPAGNE
(Roses in a Champagne Glass)
Oil on canvas, 31 x 24 cm (12³⁄₁₆ x 9⁷⁄₁₆″)
The Burrell Collection
Glasgow Museums & Art Galleries

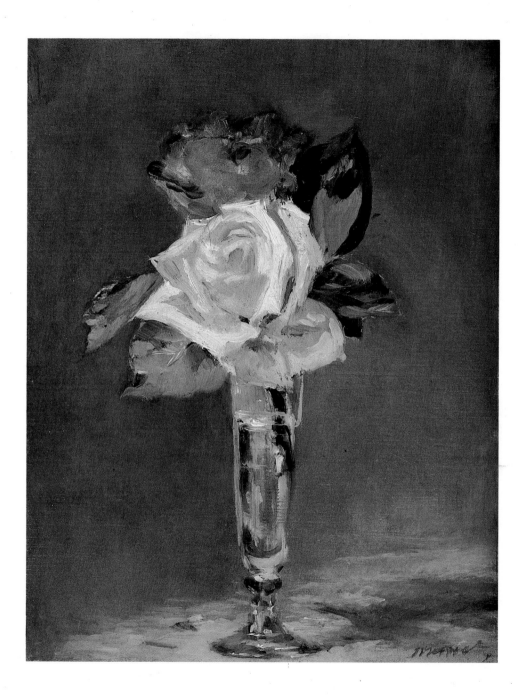

In an article published in the Revue Moderne et Naturaliste during Manet's lifetime, Paul Alexis described a certain salon at which the guests included leading writers, artists, and politicians. When the men had congregated in the smoking room, one stayed behind to talk to the women: Manet.

The fact is that Edouard Manet is one of the five or six men of present-day Parisian society who still knows how to talk to a woman. The rest of us, feverish analysts, desperately ambitious or dreamily hypochondriacal, are too bitter, too distracted, too deep in our obsessions: our forced gallantries make us resemble bears dancing the polka; we may pretend to have velvet paws, but our claws, suddenly appearing, frighten and scandalize; our imagination fails to caress like the fans of our partners. Edouard Manet is a happy exception.

While we have him in range of our opera glass in the gentle glow of a great party's candles, amidst a bouquet of lovely women, let us quickly sketch the black-suited figure of this perfect man of the world. The elegant creatures surrounding him kindle a brighter flame in his brilliant, deep-set eyes. His mobile and mocking lips assume a graceful shape in addressing these parisiennes. The two long pointed tips of his chestnut beard row their way through the fragrant atmosphere like a pair of oars. And the nostrils of his delicately irregular nose dilate: he smiles! he is happy! He must have just launched some penetrating remark. Friendliness, wit, good manners, all spiced with an originality born in the free air of the studio—that is our man. Someone fond of him and close to his heart described him to me, the other evening, in three words: "A great child!" Yes, a great child, sometimes! . . . with a candor and a courage which explode every moment in his work and bring him into the company of genius.

ROSES, OEILLETS, PENSEES
(Flowers in a Crystal Vase)
Oil on canvas, 32.6 x 24.3 cm (12⅞ x 9⅝″)
National Gallery of Art, Washington
Ailsa Mellon Bruce Collection

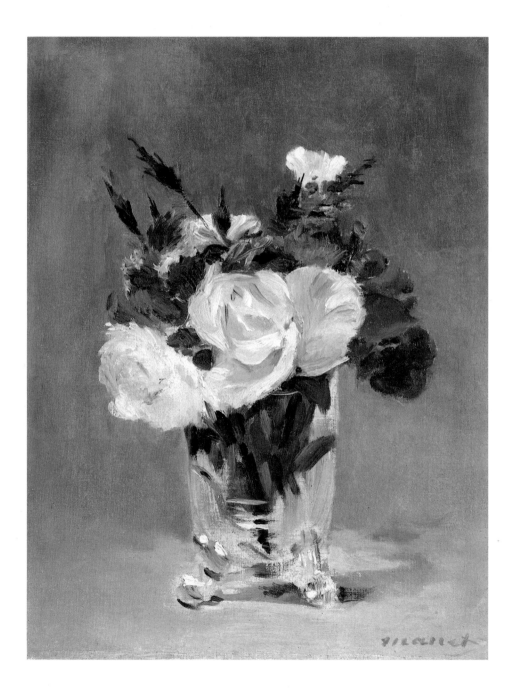

Stéphane Mallarmé met Manet in the early 1870s when the poet first arrived in Paris. They remained intimate until Manet's death. Manet painted Mallarmé's portrait in 1876. Mallarmé's portrait of Manet appeared in his Divagations, published in 1897.

That a tragic fate—aside from the fact that he was cheated of glory by Death, the universal conspirator—that a harsh and hostile destiny should have denied a man pleasure and grace disturbs me: not the vilification of the latest—and instinctive—reinventor of our great pictorial tradition, nor the fact of a merely posthumous gratitude. Yet amid the disappointments and vexations, behold the virile naiveté of a faun in putty-colored greatcoat, his thinning blond hair and beard going smartly gray. To all appearances a café wit, and elegant; yet in the studio, a demiurge flinging himself upon the canvas in frenzy, as if he had never painted before—what was once a precocious talent for unsettling us, here pursued with happy *trouvailles* and sudden mitigations: a lesson to my daily attendance, a lesson that one must risk oneself entire and anew each time, a total virtuality even while remaining, quite deliberately, oneself. How fervently he used to say, in those days, "The eye, a hand,"—it all comes back to me now.

Manet's eye—the eye of generations of city-bred childhoods, when brought to bear, quite new, virginal and abstract, on an object, on persons, sustained to the last the immediate freshness of the encounter, gripped in the talons of a glancing laugh, teasingly exorcising the exasperations of what would turn out to be the twentieth sitting. Manet's hand—its pressure registered as distinct and ready—expressed how mysteriously the limpidity of looking penetrated, in order to order, lively and laved, profound, intense, or obsessed by certain black contours, the masterpiece, new and French.

LILAS ET ROSES
(Lilacs and Roses)
Oil on canvas, 32 x 24.7 cm (12⅝ x 9¾")
Private Collection

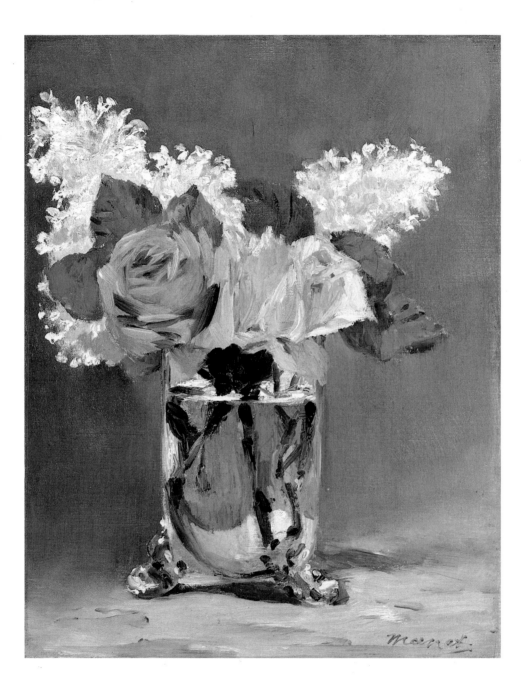

Believing that he was suffering from rheumatism, Manet visited a clinic just outside Paris at Bellevue in 1879. The next year he returned, renting a house and submitting himself again to hydrotherapy. There follow extracts from letters that speak of his sense of isolation and his hope for a cure. The first is to the artist Zacharie Astruc, the second to Mallarmé.

As you say so well, time is a great healer. Consequently I'm counting heavily on it, living like a clam in the sun when there is any, and as much as possible in the open air; but even so, the country has charms only for those who are not obliged to stay there....

 Till soon, my dear friend, good luck and good health—that's still what's most precious of all.

It's been a long time since I've had any news of you—quick take up your pen and tell me about what's been happening in your part of the world. I feel fine from the stay in Bellevue—air excellent—I hope in three or four months to benefit by it—besides, I am prepared to undergo any discomfort in order to regain my health. Till now, the bad weather has kept me from working very seriously—I am impatiently waiting for a good spell to last.

LILAS DANS UN VERRE
(Lilacs in a Glass)
Oil on canvas, 26.5 x 21 cm (10⁷⁄₁₆ x 8¼")
Private Collection

The treatment that Manet was receiving challenged his fortitude. This letter to Méry Laurent, one of his closest friends, affirms his determination to be cured. Summer 1880.

As for penance, my dear Méry, I am constantly doing it, and as never before in my life! However, if it all comes to something, there will be no reason for regret. Shower baths are an agonizing torment here—far from being as comfortable as they are at Béni-Barde. One of these mornings I'm going to take a little excursion. I hope, dear Méry, that you'll write me all your news soon. Don't let the Barroil matter [the purchase of a painting] hang fire, I really need cash—here everything costs more than in Paris, and no deductions are made for my shower baths—I'm quite impatient for good weather, so I can get back to work.

ROSES MOUSSEUSES DANS UN VASE
(Moss Roses in a Vase)
Oil on canvas, 55.9 x 34.3 cm (22 x 13½″)
Sterling and Francine Clark Art Institute
Williamstown, Massachusetts

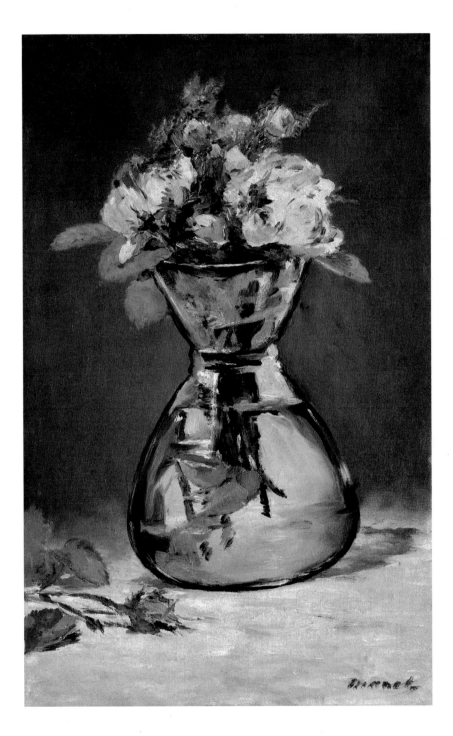

Manet and Mallarmé had worked together on an edition of Edgar Allan Poe's "The Raven," published in 1875. In the summer of 1881 Mallarmé approached Manet at Versailles with an invitation to make further illustrations for some new translations of Poe that he had made. Manet could not find the strength to accept; then he thought better of it. In the end he made drawings for "Annabel Lee," "The Sleeper," and "The City in the Sea."

Dear Captain,

You know how much I should like to embark with you on any voyage at all. But today it's beyond my strength. I don't feel competent to do what you ask. I have no models, and above all no imagination. I would produce nothing worthwhile. Please forgive me.

I'm not very pleased with my health since I've been in Versailles. I don't know if it's the change of air or the variations in temperature, but it seems to me I'm not feeling so well as I did in Paris; perhaps I'll get over this. . . . I am returning the pages you sent—someone more intelligent than I will be able to make good use of them.

My dear friend,

I am remorseful, as well as apprehensive that you might be annoyed with me, for when I come to think of it, it's selfish of me not to have accepted your project. But certain things you suggested seemed impossible, among others the woman seen in bed through a window. You poets are terrible, and it is often impossible to realize your imaginings. Lastly, I wasn't feeling very well then, and I was afraid I couldn't manage to get the work done in time. If it is possible to make the arrangements all over again when I return to Paris, I'll try to measure up to the poet and the translator, and besides, I'll have you there to spur me on.

BOUQUET DE PIVOINES
(Bouquet of Peonies)
Oil on canvas, 55 x 42 cm (21⅝ x 16½")
Private Collection

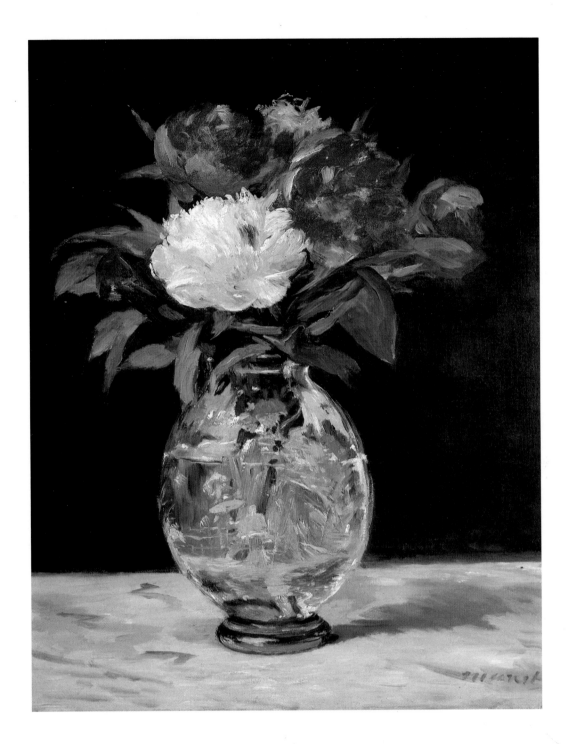

Georges Jeanniot was a painter who had met Manet a few years before the encounter described here. His reminiscences of Manet were published in <u>La Revue Moderne</u> *in 1907.*

When I returned to Paris in January 1882, my first visit was to Manet. He was painting *A Bar at the Folies-Bergère* at the time, and his model, a pretty girl, was posing behind a table covered with bottles and food. He recognized me at once, held out his hand, and said: "I'm so sorry, please forgive me, I must remain seated, I'm having difficulties with my foot. Do sit down over here...."

Others came in, and Manet stopped painting, sitting down on the couch against the right-hand wall. It was then that I saw how sorely his sickness was trying him, he walked with a cane and seemed to tremble; yet he remained in good humor and spoke of his imminent recovery....

I told him as well as I could how I felt about his painting and I had the happiness of seeing dawn in his eyes, which his sickness had not dimmed, an emotion that remains one of the most precious memories of my life.

ROSES, TULIPES, ET LILAS DANS UN VASE DE CRISTAL
(Roses, Tulips, and Lilacs in a Crystal Vase)
Oil on canvas, 54 x 34 cm (21¼ x 13⅜")
Private Collection

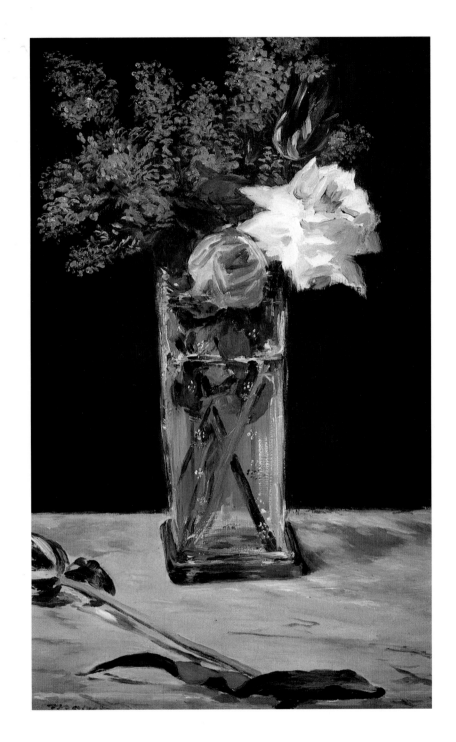

Jeanniot records some of Manet's remarks about painting made during the visits of 1882.

I came back to see him during my stay and he told me things like this: Concision in art is a necessity as well as an elegance; a man who is concise makes you think, a verbose man bores you. Always move in the direction of concision. In a figure look for the highest light and the deepest shadow, the rest will come quite naturally: often it's nothing at all. And then, cultivate your memories; nature will never give you anything but hints—it's like a railing that keeps you from falling into banality. You must constantly remain the master and do as you please. No tasks! No, no tasks!...

Color, Manet went on, is a matter of taste and sensibility; for instance, you must have something to say, otherwise good night. You are not a painter if you don't love painting more than anything else; but it's not enough to know your métier, you must also be moved. Knowledge is all very well, but for us, you see, imagination matters more.

VASE DE FLEURS, ROSES ET LILAS
(Vase of Roses and Lilacs)
Oil on canvas, 55 x 35 cm (21⅝ x 13¾")
Private Collection

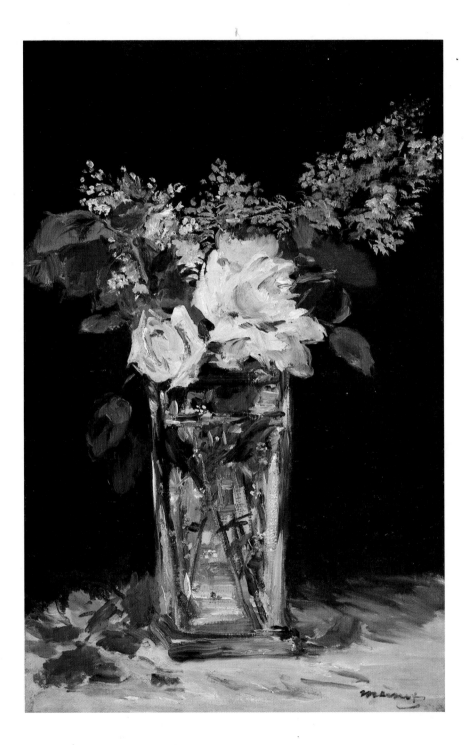

To Manet's annoyance, a report of his illness appeared in L'Evénement *of July 8, 1882.*

We learn with regret that M. Manet is at this moment gravely ill. The condition of the famous creator of *Le Bon Bock* is, however, not so distressing as some have claimed, and we do not believe his numerous friends have reason to be especially alarmed.

Manet's correction appeared two days later.

The creator of *Le Bon Bock* has sent us the following letter, which we are happy to print:

Dear Sphinx,
Your morning columns contain a bulletin concerning my health which, however sympathetic, is inaccurate. I am not ill. I simply sprained my foot before leaving Paris. Would you be so good as to reassure "my numerous friends" as soon as possible?

He made allusion to the incident in a letter to Méry Laurent.

We have no luck with the weather, my dear Méry. But maybe in the moon's next phase we'll get some sun. Whenever the sky clears I take a walk in my garden—but I must work to be entertained and even to feel quite well. I don't know who played the nasty trick last week—sending a wretched bulletin to *L'Evénement* about my health which was reprinted in all the papers! I hope you're feeling entirely well by now—send me all your news, and news in general. Sorry for my miserable handwriting, I have a dreadful pen, and I want to get this letter off tonight.

BOUQUET DE FLEURS
(Flower Bouquet)
Oil on canvas, 54 x 34 cm (21¼ x 13⅜″)
Oskar Reinhart Collection "Am Römerholz," Winterthur

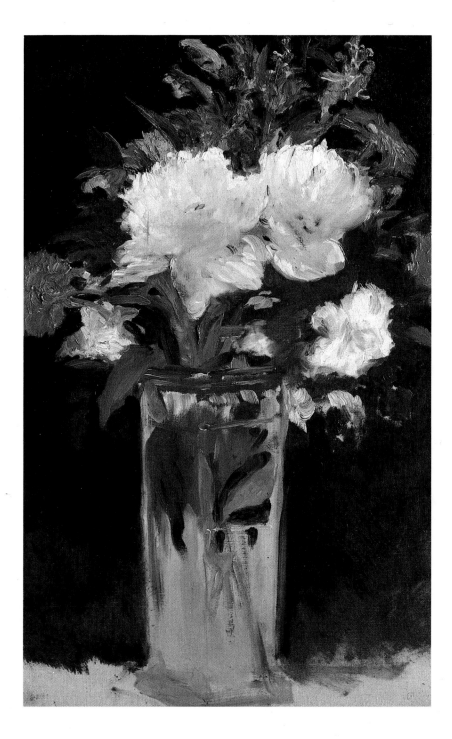

Manet could not conceal the severity of his illness from his close friends. Mallarmé's tactfully worded letter, written from his country home at Valvins, on September 11, 1882, betrays his anxiety.

For days I've longed for some word of you, but laziness and my old confidence in your health made me postpone writing. The information I was given in the Rue Saint-Pétersbourg two or three days after your departure (which sounds as if it had occurred under good circumstances) immediately reassured me, considering the absurd news of a relapse that appeared in several newspapers. I didn't even want to write you, in order not to seem to have believed such a thing for an instant.

How have you been these last two months? A word from you would give me great pleasure. Is the country air doing you more good than last year? Are you working away? I can almost see a few garden pieces on the easels, the minute I get to your studio.

Nothing new here: I fill a few pages in the morning, and spend the cloudy afternoons out in the yawl. In other words, the annual Valvins, from which I shall collect a sufficiency of strength and freshness of mind.

I have reread, remembering that you did the same thing a year or so ago, Jean-Jacques' *Confessions*: yes, it's a wonderful book.

There you are, my dear friend, our usual gossip, with the added delight that I don't have to run off to teach, and the subtracted one that I'm not seeing you.

FLEURS DANS UN VASE DE CRISTAL
(Flowers in a Crystal Vase)
Oil on canvas, 54.6 x 35.2 cm (21½ x 13⅞″)
Private Collection
Photograph courtesy Museum of Fine Arts, Boston

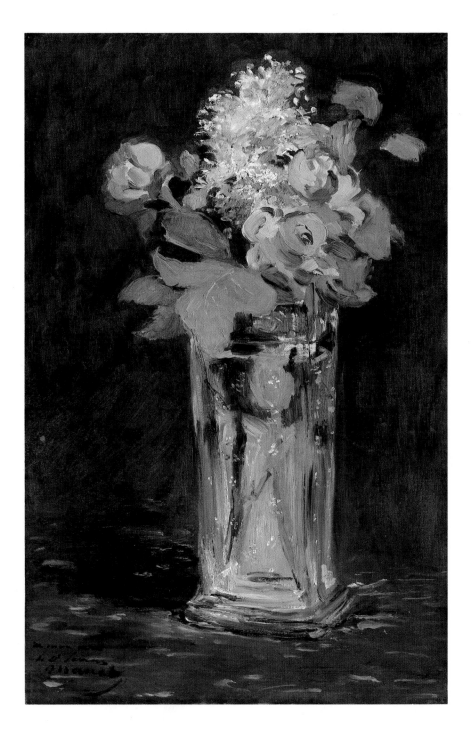

Manet made studies of his garden when the weather allowed him to be outside. Rain added to the frustration of being in the country and away from Paris. He wrote to Méry Laurent in autumn, 1882.

I was going to write to you when your letter came. I've been quite lazy, and it's taken all my friendship for you to persuade me to write at all. What a wretched month! Rain or wind every day—unlikely to make the country agreeable, especially to a sick man—my only amusements consist in carriage rides and reading, since I've hardly been able to work outside at all. You say you've lots to tell me. Why not do so in your next letter, since it will take a lot of patience to have to wait until I return to Paris. I may extend my stay here until the end of October, since I'd like to come home in a little better shape, and the two months here have really done me some good.

Goodbye, my dear Méry, I send kisses. Write me a long letter full of news. I hear nothing at all where I am, and I'd love to know about our mutual friends.

OEILLETS ET CLEMATITES DANS UN VASE DE CRISTAL
(Pinks and Clematis in a Crystal Vase)
Oil on canvas, 56 x 35 cm (22 x 13¾")
Musée d'Orsay (Galerie du Jeu de Paume), Paris
Photograph by Routhier, Studio Lourmel, Paris

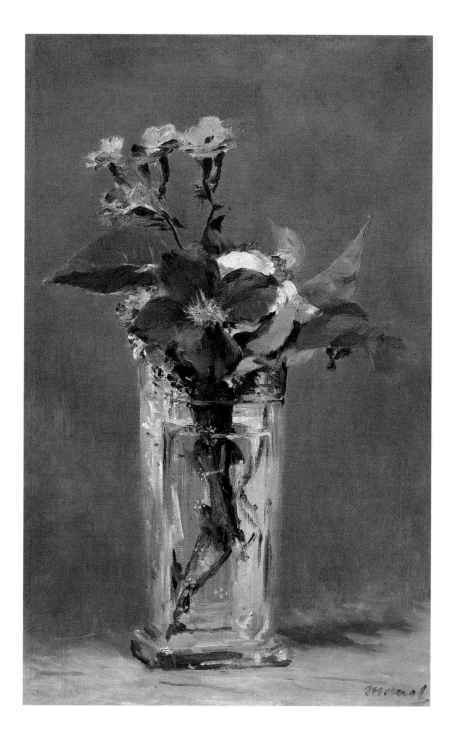

Gaston Latouche was a painter who had posed chatting to the barmaid in Manet's A Bar at the Folies-Bergère. This account describes Manet in his last months.

Exhausted by his disease, the master rested on a couch, scattering jokes and sayings among us which would have made the fortune of any journalist. We listened to every word, and those moments we spent with him were delicious indeed....

The disease grew more malevolent, gradually sapping this robust constitution. During his last summer Manet went to Rueil to stay in Labiche's house. But whatever good the fresh air and the sun might have done him was partly canceled out by one thought: Paris!

Manet was a Parisian, he loved Paris, and sorely missed the animation of the great city. Visits from friends in his studio, the conversations among intimates—he needed all that. We cheered him up as best we could, and god knows we lectured him! To no avail—and it was with a profound sigh of relief that he returned to Paris. Alas, the disease was soon to deprive him of his strength as it had already, and long since, weakened him morally. He was supposed to follow a diet and no longer to see people, but to spend the evenings quietly at home. Hence he was no longer to be seen at our meetings at the Nouvelle Athènes where he so much liked to go and chat, smoking in the famous corner we used to call the Omnibus.

LILAS BLANCS DANS UN VASE DE CRISTAL
(White Lilacs in a Crystal Vase)
Oil on canvas, 56.2 x 35 cm (22⅛ x 13¾")
Private Collection

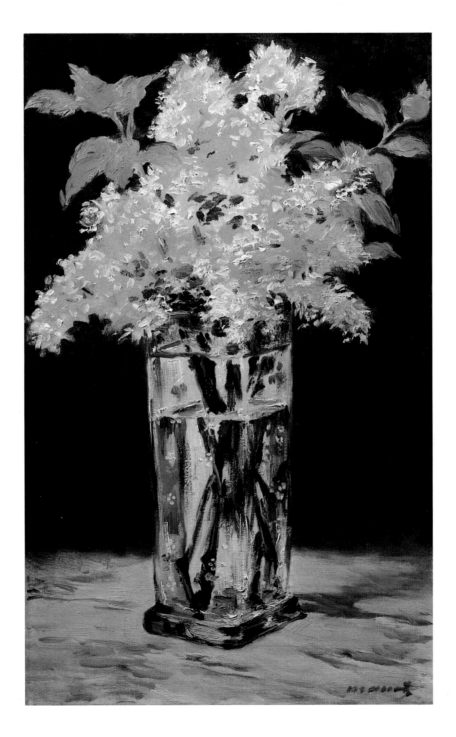

An account of Manet's operation, undoubtedly somewhat fictionalized, appeared in <u>Le Figaro</u> *of April 20, 1883.*

Yesterday Manet the painter suffered the amputation of a leg. During the last six weeks that he has kept to his bed, there has always been the possibility of this cruel operation. But given the patient's weakened condition, there had been hesitations to effect it. Manet having regained some strength in the last few days, his doctors determined to attempt the amputation, provided their patient was willing to undergo it. On Wednesday one of Manet's friends came to see him and reported that a man he knew, in a similar situation, had permittted such an amputation, and that subsequently he was well on the way to recovery.

"Well then," Manet said, "if there is nothing else to do, take off the leg and let's be done with it!"

Without wasting a moment, the friend in question informed Doctor Marjolin, and the operation was scheduled. Yesterday, at ten o'clock, Doctors Tillaux, Siredey, and Marjolin visited the patient, whom they found in excellent condition to face such an ordeal. The limb to be amputated was in a deplorable state; gangrene had set in and reduced the flesh to such a degree that the toenails came away upon contact.

The patient was chloroformed and the operation performed by Doctor Tillaux, assisted by Doctors Siredey and Marjolin. The amputation was made below the knee, Manet experiencing no pain. The day went as well as could be expected, and last night, when we came to inquire as to his condition, there was no indication of serious complication.

FLEURS DANS UN VASE
(Still Life with Roses and Tulips in a Dragon Vase)
Oil on canvas, 56 x 36 cm (22 x 14⅛")
Private Collection

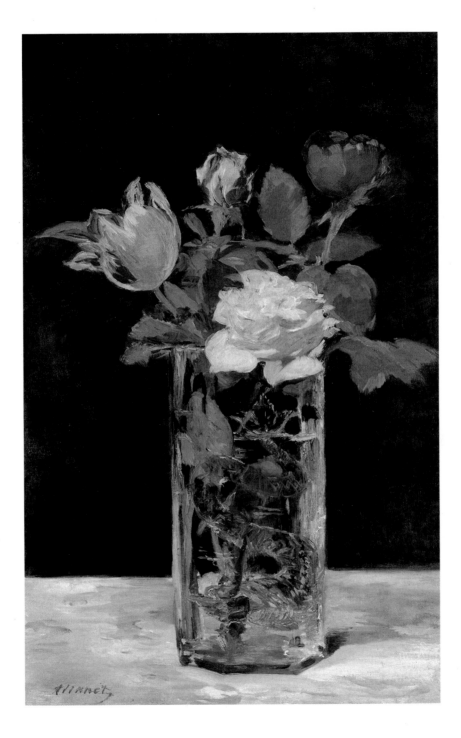

Gaston Latouche was one of Manet's last visitors.

Death came slowly, but it came. The last time I saw poor Manet, he had undergone the painful operation on his leg we all remember. I can still see his fine head silhouetted against the white pillow that emphasized the ashen color his face had assumed, already invaded by the shadows of death.

I stayed with him only a few moments; he was supposed to avoid fatigue. We said little—I tried to keep a smile on my lips for his sake, and I felt the sobs tightening my throat. Yet Manet managed to laugh, and to make me laugh—I, who had promised to cheer up the dear companion, to whom I was so sublimely devoted. I left without finding a word to say, pressing Madame Manet's hands and those of good Leenhoff. Two days later Manet died.

LILAS BLANCS DANS UN VASE DE VERRE
(Bouquet of Lilacs)
Oil on canvas, 56 x 46 cm (22 x 18⅛")
Nationalgalerie
Staatliche Museen Preussischer Kulturbesitz, Berlin (West)
Photograph by Jörg P. Anders

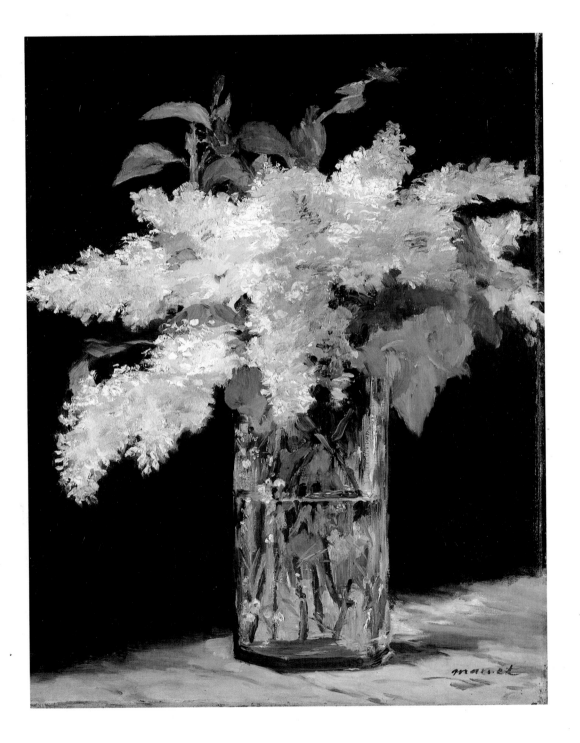

These passages describing Manet's funeral are extracted from an obituary by Jules-Camille de Polignac that appeared in the newspaper Paris *on May 5, 1883.*

The hearse is in front of the door....On the sidewalk opposite, passersby, girls buying their lunch, people who have come to have a look, standing on tiptoe to watch, open-mouthed—voyeurs of death.

At the windows appear bright clusters of faces, the white patch of a maid's apron or hastily pressed skirt, yellow braids, brown heads, beards, touseled babies in the broad brushstroke of dim interiors.

No sky, no sun; bright clouds spread a gentle gray in the open air of the "street picture."...

The procession stops at the portal of Saint-Louis d'Antin, where a catafalque has been set up in front of the high altar glittering with candles. Manet's body is brought in, followed by his family and a small number of friends, and immediately the choirs burst into song, followed by the mournful solos of the service for the dead....

Outside, in front of the church door, where most people remained, groups formed and conversations struck up. "Not much use carving him up that way," one gentleman said.

The procession resumes its slow course. Boulevard Haussmann, Rue La Boétie, and Rue Marbeuf, to the Trocadéro. The Passy cemetery is a few steps farther.

Here the sky was washed clear and the way seemed pleasanter. After the long monotony of the streets, we were glad, in our weariness and our melancholy, to glimpse all of a sudden, between the buildings, the luminous unfolding of Paris against the bright sky; and in this Avenue du Trocadéro the two green lines of trees silhouetted against the blue air, and closer to us, the brighter patch of the new green leaves separated by fragments of sky.

LILAS BLANCS DANS UN VASE DE VERRE
(Vase of White Lilacs and Roses)
Oil on canvas, 55.9 x 46 cm (22 x 18⅛″)
Dallas Museum of Art
The Wendy and Emery Reves Collection

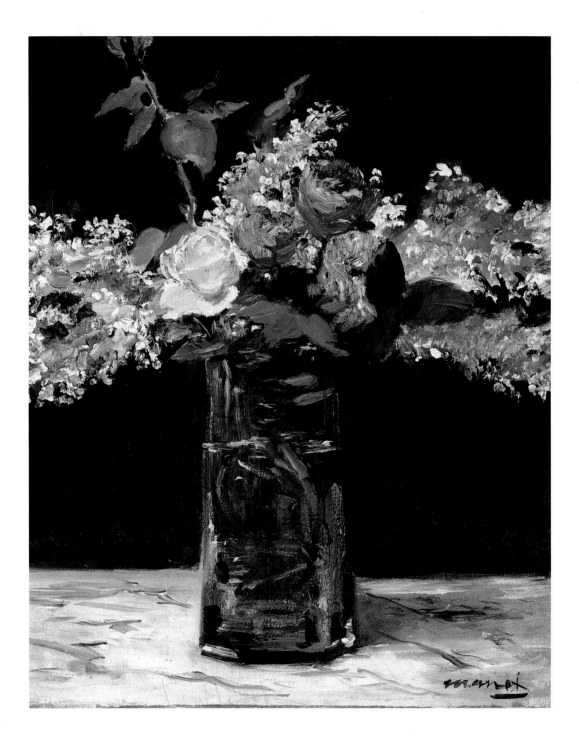

This valedictory description of Manet's empty studio is by Edmond Bazire, author of the first monograph on the artist.

Manet's last studio was in the Rue d'Amsterdam, a few steps from the Place Moncey. It was a high rectangle constructed at the rear of a courtyard, far from the bustle of the street. Once through the *porte cochère*, you noticed the huge panes sticking up above the roofs on either side. The studio was devised to be flooded with light. It was furnished in the simplest possible manner: an overstuffed sofa, a daybed, a few armchairs, a mahogany desk covered with papers and brochures, a leather stool— and that was all. Yet this huge shed seemed almost cramped: the walls vanished under the canvases hanging there, old and new; works of his earliest youth and the very latest projects. Stretchers were leaning on easels set around the room, the motifs brushed in. As you came in, there were two paintings of bouquets, one of pink roses, pinks and leaves, the other of roses and white lilacs, an explosion of freshness, quivering in the crystal vase where the painter's imagination had put them. It was to paint these canvases that Manet had taken up his brush for the last time; the first one dates from February 28, the second from March 1. Having finished them, he returned to his rooms, and never came out again.

This studio tells a whole life story. It is the summary, in a sense, of a career as studious as it was stormy....You turn away, you glance around the long room, everywhere reminded of a vanished figure whose laughter and high spirits filled this now dreary space, and you leave with a heavy heart, struck by the beauties of the work, saddened by the workman's departure.

ROSES DANS UN VASE DE VERRE
(Roses in a Glass Vase)
Oil on canvas, 56 x 35 cm (22 x 13¾″)
Private Collection

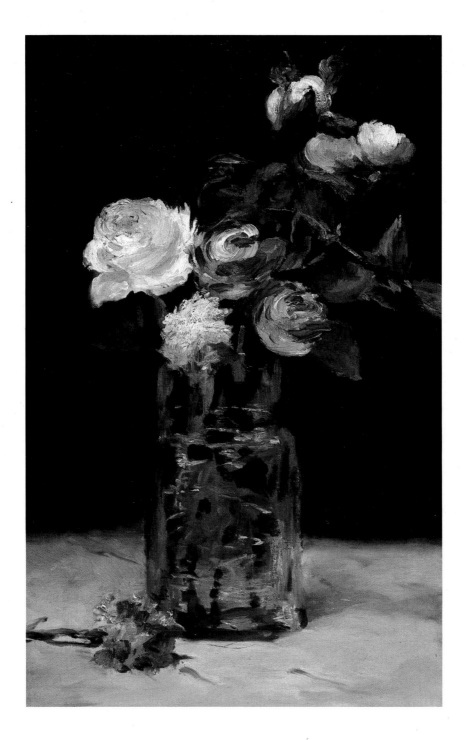

ACKNOWLEDGMENTS

I would like above all to thank my co-author, Andrew Forge, with whom I have the privilege to work, and the many people who have helped realize this book: my trusted editor, Bob Morton, his assistant, Harriet Whelchel, designer Judith Henry, as well as Beverly Fazio, Barbara Lyons, Margaret Rennolds, and Shun Yamamoto at Harry N. Abrams, Inc.; Bill Acquavella; Chrysostome Apsis; Bill Beadleston; Marc Blondeau; Françoise and Philippe Brame, Bernard Lorenceau, and their assistants, Armelle Taillemite and Marie-Philomène de Leusse; Thierry and Pierrette Bodin; Dr. Dieter Bührle; Michel Castaing; François Chapon, *conservateur en chef* of the Bibliothèque Littéraire Jacques-Doucet, who allowed me to consult the Manet–Méry Laurent correspondence; Wendell and Dorothy Cherry; Desmond L. Corcoran, S. Martin Summers, and their assistant, Jacquie Cartwright, for their good counsel and belief in our work; the curators at the Bibliothèque Doucet and Bibliothèque Nationale; Ernie Dieringer; the late Charles Durand-Ruel, his daughter, Caroline Godfroy, and their assistant, France Daguet; my family, Esther and Norman Rosenberg, Edward and Dorothy Gordon, Ron, Stephanie, Jeremy, and Miranda Gordon, and Joseph Freidlin; Marianne Feilchenfeldt and her son, Walter; Michael Findlay; J.-C. Garreta; Noëlle Giret; Alice Goldet for her enthusiasm and encouragement; David Hamilton; Richard Howard for his superb translations; Susan Kitsoulis; Aki Lehman; Leslie, to whom I give this book as a bouquet; Heidi Loewen; my lovely Mary Jo; Jill Mathews; Peter Mitchell; David Nash and his assistant, Diana Hamilton-Jones; Otto and Marguerite Nelson for their exceptional photography; Veronica Pastel; Elizabeth Reid; Alexandre Rosenberg and his assistant, Liliane Samuel; Madame Denis Rouart and the members of her family for so kindly permitting us to publish the Manet–Méry Laurent correspondence; Georges Routhier, his wife, Andrée, their son, Jean-Michel, and their assistant, Myrthis Bonijol; Berthe Saunders; Herbert Schimmel; Susan Seidel; Dr. Lisbeth Stähelin; Colonel Daniel Sickles for so graciously allowing us to publish the Manet-Mallarmé letters in his private collection; my agent, Marian Young; Shiela Zelermyer; and all the private collectors who welcomed us into their homes and granted us permission to reproduce their paintings.

Robert Gordon